Fra Angelico

An Art Conversation – Junior Student

By Antoinette James

Fra Angelico

An Art Conversation – Junior Student

By Antoinette James

JC
J Crowd Publishing

antoinettejames.com An Art Conversation - Junior Student
Fra Angelico
Copyright © 2017 by Antoinette James. All rights reserved

No part of this publication may be reproduced, stored
in a retrieval system or transmitted in any way
by any means, electronic, mechanical, photocopy, recording
or otherwise without the prior permission of the author.
The opinions expressed by the author are not necessarily those
of J Crowd Publishing.

Published by J Crowd Publishing
J Crowd Publishing is an in-house publishing company.

Book design copyright© 2017 by J Crowd Publishing. All rights reserved.
Cover and interior design and layout by Antoinette James

Published by J Crowd Publishing
Published in New Zealand

ISBN - 9781545581339

Contents

Artist Profile..5

Style and Influences..9

Gallery Samples...13

The Annunciation...13

Noli me Tangere ..15

Coronation of the Virgin...17

The Disposition of the Cross....................................19

St Lawrence Distributing Alms.................................21

Research Discussion Topics.....................................23

Discovering new insights from the canvas..............24

Colour in..29

Feldman's method of Art Criticism31

Fra Angelico

1395 - 1455

---Over View---

Fra Angelico was born in Vicchio, near Florence, Italy, named Guido di Pietro - Guy, son of Peter. Experts estimate the year of his birth to be 1395 on account of documents recording him as a layman and painter in 1417 and evidence he took holy orders shortly after. Typically, for the time, entrance into a monastery was in late teens.

It was at San Domenico, Fiesole where he, being extremely pious, embraced the humble life of monastic living. Although he placed the holy above the material, he started his illustrious artistic career unpretentiously decorating manuscripts.

His early Renaissance style and expertise working with gold leaf was quickly recognised, making him in great demand by secular and church patrons alike.

It was at this time in history, that artists were commissioned for the sake of art's aesthetic value, rather than solely for religious readings. In Florence, secular institutions and individuals were commissioning many art works; and this in turn allowed the Renaissance style to develop and flourish.

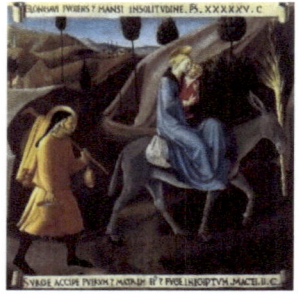
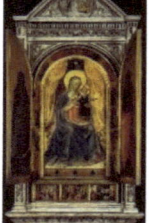

Examples of Angelico's secular commissioned works, *The Flight to Egypt* (left) painted along with *Massacre of the Innocent* both commissioned by Piero dé Medici.

Angelico's first dated major commission was by the secular Guild of Linen Weavers of Florence in 1433, *The Linaiuoli Altarpiece.* (right)

Angelico honed his skills with perspective, colour and the use of light and shadow making his art the most impressive works of this period.

His fame, however, undoubtedly rests on his biblical frescoes (wall paintings). Many of his frescoes in Rome have not survived the centuries, but there are a few that can be viewed in Italian churches and in the Vatican.

Some of his more celebrated works, by papal commission, can be found in the small private chapel of Nicholas V, depicting the life of Saint Lawrence - a martyr of the early Roman Catholic Church. (left)

Fra Angelico showed extraordinary ability at blending order and serenity of monastic life with compassion for the state of man's heart. Many of his frescoes were painted

in monastery prayer rooms, known as cells; among them, *The Annunciation*, (p. 13) and *Noli Me Tangere*, (p. 15) purposed for quiet prayer, reflection and mediation.

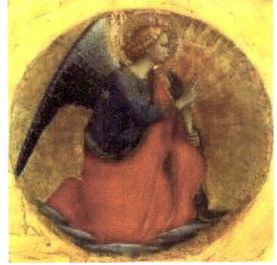

Like many artists of this time, Angelico excelled in his skills with gold leaf. Perhaps, his most stunning gold leaf altar piece would be, *The Coronation of the Virgin* 1434-35. (p. 12)

His trademark - beautiful bird-like wings.

Angelico painted angels in realistic human form, but embellished their wings with bright primary coloured feathers. Careful brushwork ensured each bird-like feather was emphasized.

In the turbulently violent time in which Angelico lived, he sought and found enough inner peace to produce works of significant religious benefit in line with distinctive doctrines of the Roman Catholic Church. Peace and quiet, he said, were prerequisites for the production of great art.

Fra Angelico could have become wealthy, such were the number of commissions he took. However, all the payments for his altar pieces and frescoes, went to the monastery.

His whole life was one of modest piety. Many junior artists worked for him, yet with all his heralded success, he remained humble; always crying in meekness when painting the crucifixion of Christ.

Very little was documented about painters in general during

Fra Angelico's life time, as artists were not thought noteworthy in the fifteenth Century. What has been recorded, albeit elaborated, can be found in two editions of *Lives of Artists*, published some hundred years after his death by Italian born Giorgio Vasari. He notes, Angelico - a pious considered artist, who put God above his talent.

Fra Angelico was known as Angelic. In Italy, he is called 'Beato' - the Blessed.

Angelico died in Rome in 1455 and was buried in the monastery of Santa Maria sopra Minerva where his effigy can be viewed today.

The poet Lorenzo Valla wrote the words carved on the tomb, under his feet.

> 'Let me not be praised as another Apelles,
> but because I gave my riches O Christ to Thy people;
> For the deeds that account on earth
> are different from those in heaven.'

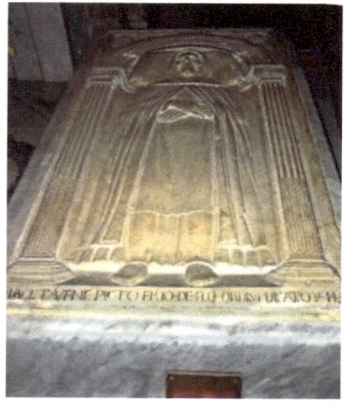

---Style and Influences---

No one can deny that Fra Angelico had innate artistic talent. For an artist of the Catholic Middle Ages, constrained by conformity of church edits, he showed a natural ability in understanding how to use light and shade, use colour, recognise the importance of narrative in an individual painting and most importantly, experiment with perspective. His profound advancements in how the canvas read, marked his paintings as Early Renaissance rather than Medieval.

His artistic flare for beautifully decorated manuscripts, was out-weighed by his extraordinary wall paintings, made possible in the dry Italian climate. It was his wall paintings, or frescoes that declared his place as one of Italy's and indeed the world's most famous fifteenth century artists. Fra Angelico painted saints as normal, everyday people, in the real world, doing real-world duties rather than holy etheral beings.

Although, there is much individuality in his work that we can recognise running through all his surviving paintings, (his wonderful sense of decoration and ability with colour), we can, however, clearly note changes in his works over his life time.

For clarity, art historians have divided his career into three broad phases.

Firstly, Fra Angelico painted within strict confines of Catholic dictates. Most of the early years of his career, he illuminated manuscripts, as was the occupation of young monks

of this era; miniature works were thought to test monks moral fortitude and mental discipline.

(previous page)This example is thought to be the hand of Fra Angelico, completed at San Domenico, Fiesole around 1430. Such works show detailed intricate jewel-like precision in gold and expensive blue pigments.

Secondly, over time, a more innovative brush emerged. This reflected innovations across the board; art became an experience beyond the walls of monasteries and churches and painters, carvers and smiths started competing for patronage.

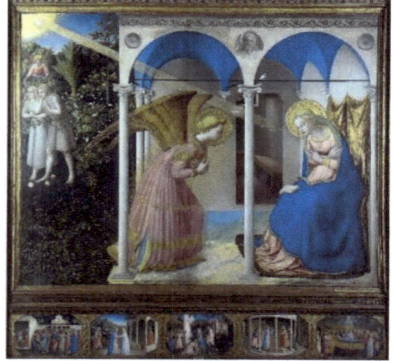

It is at this time, altar pieces were constructed displaying greater grandeur exhibiting tradesman's precision. The Annunication 1433-4, (left) is an example of an obvious turning point for Angelico, as he is able to be more expressive producing a clear narrative.

Thirdly a "coming into his own" as he excelled in the expanse and freedoms of large walls painting pictorials known as frescoes. (right)

Italian churches and houses of this era were constructed with small windows providing large areas of uninterupted expansive walls to decorate. This architectural trend was adopted to help keep the extreme heat of the summer and glaring bright sunlight out of the living spaces, making for cooler dwellings.

Italy quickly developed and perfected techniques that permanently adhere the paint to the plastered walls.

Fra Angelico gained his fame in this form of art. His vision to express and document large narratives or pictorials wooed clergy and laymen alike.

Many of the frescoes attributed to Angelico are so large and grand and so numerous experts doubt he painted everything on his own. However, it is universally accepted that he had an active hand in each part of the process.
Art restorers have found evidence that he himself drew the under sketches, or *sinopie*.

Fra Angelico was called to Rome by successive popes. In a time before church reformation, Renaissance style and delivery was unchallenged and frescoes burgeoned, making the master – Fra Angelico in great demand.

---*Artist's Gallery Sample*---
The Annunciation 1433-34 Museo Diocesano, Cortona.

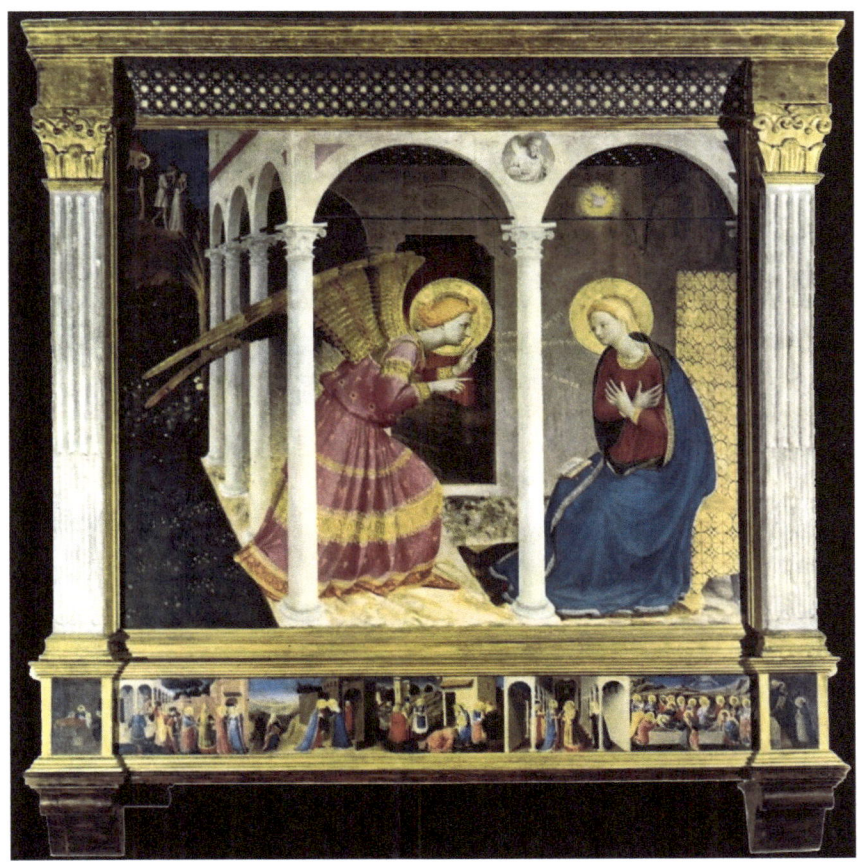

As we look around the annunciation painting we cannot but feel a sense of urgency - In the left-hand top corner of the painting we see Adam and Eve being expelled out of the Garden of Eden at "knife point". In the centre, the herald angel, Gabriel points his right-hand index finger toward Mary gaining her attention. A carved figure of God, an expression of participation, can be noticed above the middle column of the portico with a dove in flight, representing the Holy Spirit. Gabriel's golden utterances

are painted in dart-like projections captured by Mary's responsive, reflective posture. She has been abruptly interrupted from her devotional reading. She sits in the portico leaning toward the angel crossing her arms in respective reverence, making sense of the words she is hearing.

Interesting things to note – If Mary were to stand, her head would touch the starry ceiling. Eve is the only figure who looks directly at us, reminding us that we too are sinners. And the *Predella*, or foundation, depicts the time-line of the life of Mary, from her birth to death.

Contrasts in attitude between his 1450 Annunciation (right) are marked.
The latter shows a quieter, sombre, more relaxed scene than the earlier. Adam and Eve look to be exiting the Garden of Eden in a more orderly manner.

 Perhaps the two depictions are reflections of Angelico's change in attitude of heart from exuberance of youth, to wisdom and understanding of the matured mind. Also, a change in lineal perspective can be seen between the two compositions. The latter showing a less flattened aspect.

Both the paintings are meditative. In the darker distance, the mortal first Adam with hope dashed, is superseded by the good news expressed in the foreground, the announcement of the soon arrival of Christ, the second Adam.

An Art Conversation – Junior Student Fra Angelico

Noli Me Tangere 1441-45 Monastery of San Marco

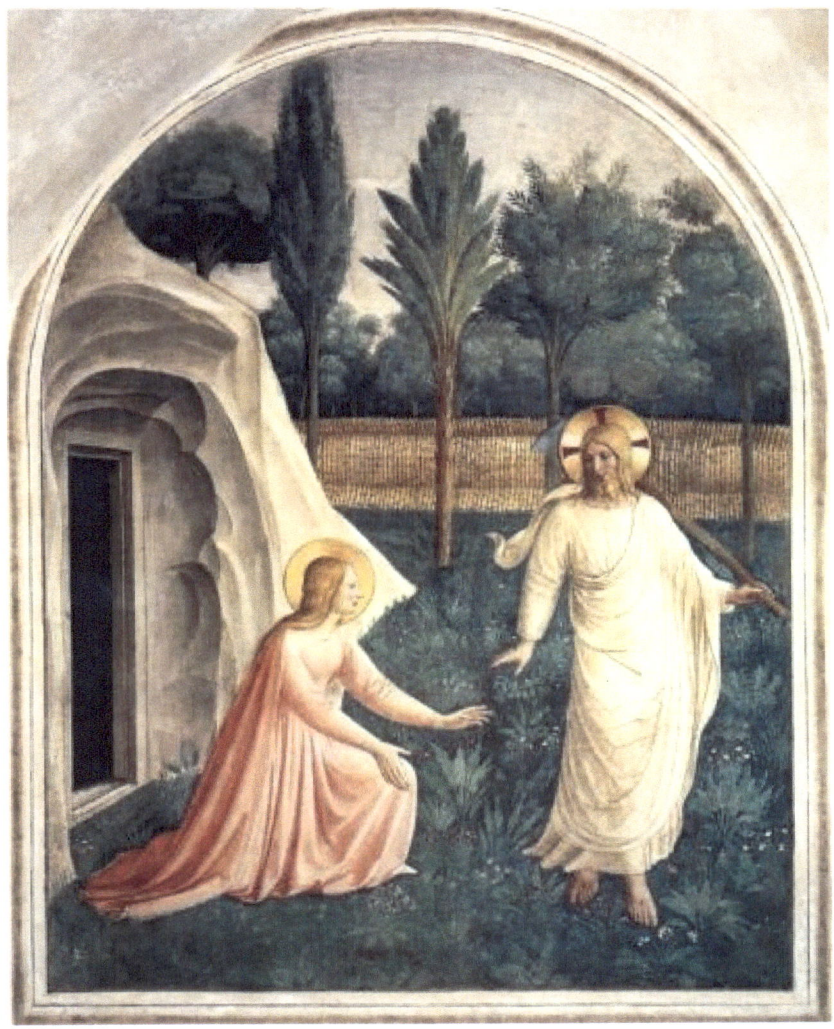

This fresco was painted on a wall in cell one, monastery of San Marco, Florence as part of a series of reflective biblical accounts. Fra Angelico, painted many frescoes here; so many in fact, that critics suggest that he could not have worked on them alone. However, historians believe he would have had strict

Here Mary, the first to the open, empty tomb after Christ's burial, initially mistakes the risen Christ for a gardener. Notice the hoe Angelico took license to paint, leaning over Jesus' left shoulder.

The hoe denotes the mistake Mary has made and bids the meditating monk to engage in the meaning. Note Mary is captured kneeling in wonder and worship, her arms full of action and honour, her face bearing recognition and intent; He has said "Mary." And she has realized that it is the risen Lord; risen as He and ancient writings stated he would.

Angelico has also intricately detailed the vegetation, Christ's garment and the tomb to emphasis the total miracle that has just taken place, heralding a new season of hope. The fence suggests this is not a random tomb; it was the protected and cared, unused tomb of the still alive Joseph of Arimathea, Jesus' wealthy earthly uncle. This association and the presences of Mary underscores Christ's heart for mankind.

An Art Conversation – Junior Student Fra Angelico
The Coronation of the Virgin 1434-35 Uffizi, Florence

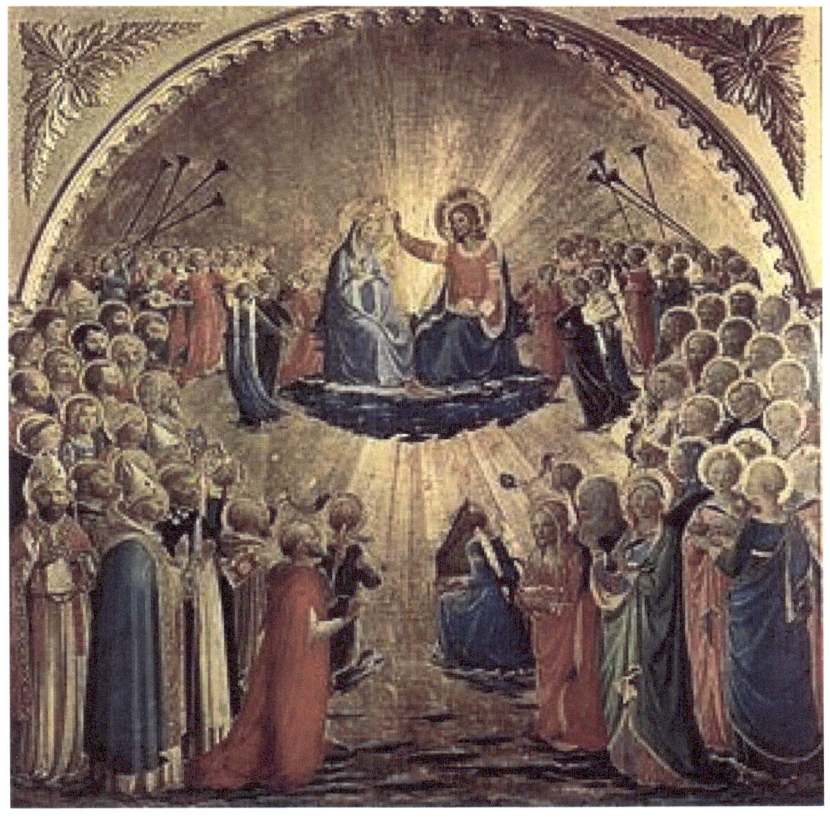

This is a fine example of an early Renaissance altarpiece - typically in gold leaf.
Here, we see the Virgin Mary's coronation ceremony as queen of heaven; unique to Roman Catholic doctrine.

 Angelico gilded the gold first, so no painted parts were compromised. A form of clay (bole) was applied initially, to areas where the leaf was to be laid. The bole was polished, then the gold leaf placed over, giving a good foundation for tooling.
 Note the very fine lines radiating out from Mary and Jesus. They are the central focus and these lines refract light to bring

further splendour to the narrative. As we look at this, Angelico's outstanding proficiency with gold leaf is clear for all to see. We also observe these tooled impressions denote radiating light which gives depth and dimension to the haloes.

Angelico also used tiny lumps of gesso under the gold where he planned to make raised ornaments. In effect his technique brought a 3D illusion to the altarpiece. A closer look shows further expertise in gold - the garments worn by the male saints look like brocade and the female's garments look like fine embroidery.

The crowning of Mary is witnessed by a host of heavenly beings, but also earthly beings. Men to the left, some of them clergy of the church, as was very usual during the early Renaissance period. Also usual, was the separation of male and female. The women are gathered together to the right. We see here Mary Magdalene, in red attire with arms reverently crossed over her chest. She is significant as representative of the saved penitent soul. She was the woman who washed Jesus feet with repentant tears and dried his feet with her hair. She looks out calling sinners.

An Art Conversation – Junior Student Fra Angelico

The Disposition from the Cross 1443 San Marco Museum

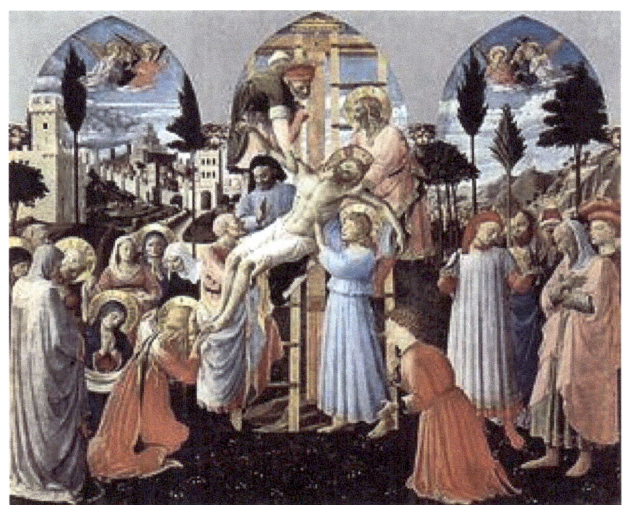

Fra Angelico painted this as a meditative piece. It was not originally painted to decorate an altar, but to be in a more minor position for quiet reflection and prayer. It was painted on a single panel and was to dress the Strozzi Chapel in the church of Saint Trinita, in Medieval Florence.

This panel was started by Lorenzo Monaco, before his death some twenty years prior. The three pinnacles of the panel are his work (not seen here).

Angelico carried this sense of 'three', speaking of the Trinity, through to the main body by dividing the people groups into three assemblies; the centre focuses on Christ, to the left the Virgin Mary with other woman attending, wearing biblical robes, and to the right men congregate wearing contemporary Florentine dress.

We can read formal religious protocols - Angelico fuses together the busyness and ultimately hopelessness of man, clearly painted by a disunity of focus and thought among those who have gathered - in contrast to the more permanent manmade structures and nature e.g. ladders, buildings, trees and cross, all stretching heavenward reminding the viewer of the ultimate redemption plan of God.

It is, however, people not nature that huddle around the body of Christ. It is for people He came, died, and rose triumphant.

Notice the inscription to the far right, '*Ecce quomodo moritur iustus et nemo percipit corde*' – 'see how a just man dies and no one feels it in their heart'.

Historically crucified on a hill outside of Jerusalem, is here skilfully translated to 15th Century Florence. The town (in the back-ground) devoid of people, symbolizing the hush of creation at Christ's death; they have come to gather around the cross. Certainly, one citizen marvels at what has happened, he holds two of the nails that pierced Christ's feet and the crown of thorns from His head.

This painting also is full of allegorical gestures very familiar to the Renaissance audience, guiding the viewer's meditation. Humility - symbolized by the gentleman's folded arms as he contemplates the cruel, long nails of Calvary. Mary Magdalen's kiss symbolizes the penitent's repentance. The Virgin Mary wringing of her hands was a traditional way of painting a grieving soul...

And we the viewers are not to be left out. The kneeling Florentine gentleman's left arm and hand opens towards us as a door, inviting us in.

To further emphasis that Christ died once and for all, regardless of generation, we note that, unlike Jesus and the two Marys, the civilians of this Florentine town are clothed in contemporary fifteenth Century dress.

Angelico was a landscape painter. See his ability in perspective. Note vanishing points.

An Art Conversation – Junior Student Fra Angelico

St Lawrence Distributing Alms 1447-49 Vatican, Rome.

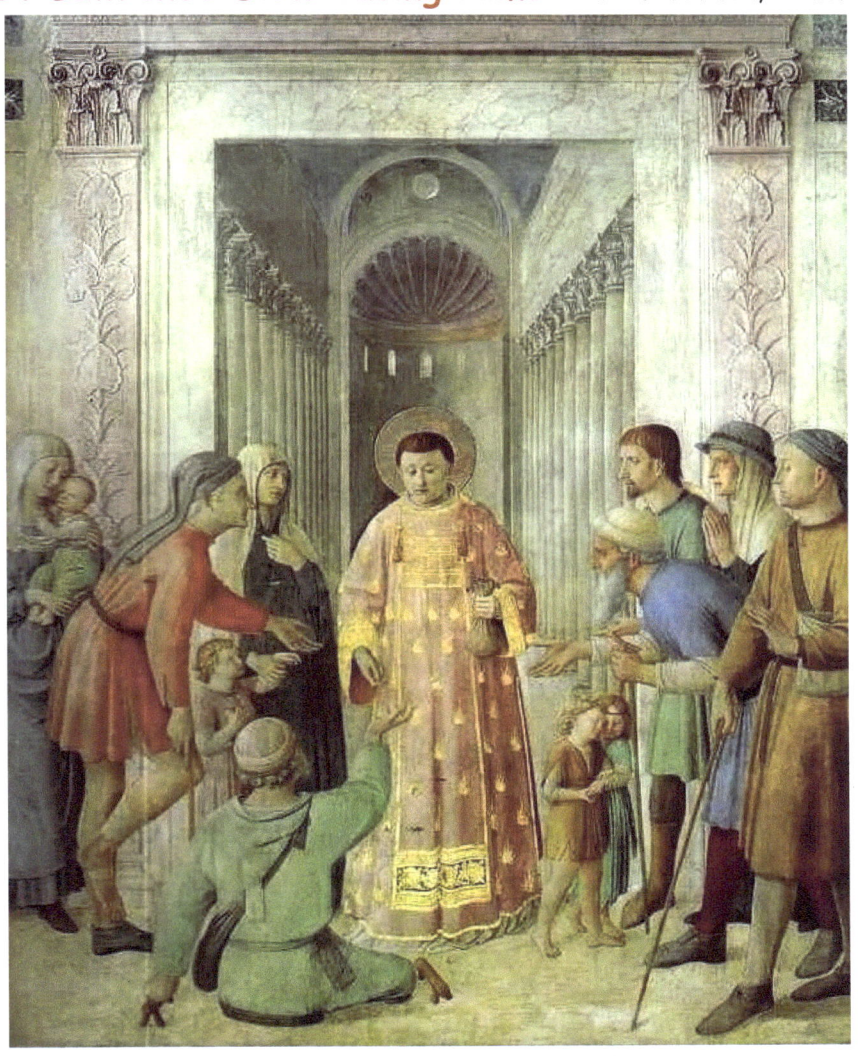

Fra Angelico left Florence in 1445 and travelled to Rome, to begin painting a cycle on the walls of the private chapel of Pope Nicholas V. This grand commission was less of a commemoration of two early martyrs. The Christian St Stephen, according to the biblical account (painted along the top) and the Roman

Catholic Church account of St Lawrence's life recorded along the bottom being of higher political significance.

The religious and political milieu of quattrocento Italy following the devastating papal schism made this very expressive account, a sort after narrative by frescoes painters of the time, which was no coincidence, making the reading all the more authoritative.

Saints Lawrence and Stephen were powerful symbols for claiming pre-eminence and legitimacy of the Roman papacy as both were deacons and both were martyred, and by association, Rome was claimed as the new Jerusalem.

Saint Lawrence, who refused to turn over the treasure to the Romans when Pope Sixtus was imprisoned defending the honour of the church. St Lawrence is numbered among the Roman Catholic patron saints of Rome.

This is, but one of the paintings in the cycle. It tells the story of St Lawrence giving the church treasure to the poor. The Saint is distributing alms to beggars, cripples, women and children on the street.

In typical Renaissance proportions, the children are painted as small adults. Notice their heads appear smaller in proportion to their bodies than the normal proportions of children. This is in line with the way children were treated, unlike the 21st century laws and societal views and parental care of them.

Although Angelico has added soul to this painting, the renaissance form and structure of horizontal and vertical lines inhibits the feeling of movement which we see later in Baroque style.

---Research and discussion Topics---

People and events at this time in history:

*Venice's golden palace

*The great dome of Florence Cathedral

*Joan of Arc -1431

*Johann Muller 1436-76

*Poet John Lydgate 1370-1450

*James 1 England

*Dante Alighieri

*The Hundred Year War

*Hussite War

*Decline of Monastic life

*Savonarola

Giorgio Vasari *Lives of Artists* 1550 and 1568

–Discovering New Insights from the Canvas–
–Curriculum Extension Activities–

(Adapted and enlarged from notes by B. Duckworth and D. Jamieson)

Creative writing

*BEFORE - write a story where the painting reflects the final paragraph.
*AFTER - write a story where the painting is the story Starter.
*CAPTIONS - Write suitable captions for the painting.
*SPEECH BUBBLES – create a bubble and stick it by the Individuals.
*MESSAGES – Some artists write messages on the painting. Do you see any? What does it say?
*NOUNS AND VERBS – Make a vocabulary list related to the painting.
*ADJECTIVES AND ADVERBS – make a vocabulary list related to the painting.

Analysing

*QUESTION TIME - In pairs, taking turns, one asks a question and the other answers.
*SIMILARITIES – Classical art was often copied by other artists. Find a copy and discuss similarities.
*Differences - ... and what is different.
*WWWWW.H – ask who, what, when, why, where and how questions.
*RELATIONSHIPS – pick up a picture each and try to establish a relationship between the two. Look for common

properties, elements or features.
*How does this painting make you feel?
*What room in the house do you think this painting is best suited?

Pre-science (Observation skills)

*I SPY - play a game of I Spy.

*SENSES - choose a person in the painting and discuss what they may be able to see, hear, smell, touch.
*WHO AM I? - One person selects a person in the painting while the other person asks up to 10 questions to identify them.
*WHAT AM I? - One person selects an object in the painting while the other person asks 10 questions to identify it.
*WHERE AM I? - One person gives one clue at a time to find out where in the picture they are pretending to be.
*FIVE CLUES - One person gives 5 clues giving the other person a chance to guess the answer.
*TRUE OR FALSE - One person makes a statement and the other person checks the painting to see if the statement is true or false.
*CLASSIFICATION - Can you identify and name the animal and its breed in the painting?
*FLORA - What Flora is in the painting?
*CREEPY CRAWLIES - Are there any bugs painted? What are their names?
*What animals are in the painting? Does it look like modern breeds?
*WEATHER - What season does the painting reflect? What type of clouds can you identify?

Antoinette James

Memory expansion (prediction/recall)

*MEMORY GAMES – View the painting then remove. How many things can you recall?
*LET'S PREDICT – In a painting that has numbered features (use numbered dot stickers) make a prediction of each numbered object.
*DISCLOSURE – Cover parts of the painting and ask what could be happening here. Uncover to see if you are correct.

Numeracy

*COUNTING – How many of a particular item can you find in the painting?
*SORT, LIST, LABEL – Sort, list and label different paintings in to sets (genres)
*SIZE – What is the size of the original canvas this painting was produced on?
*AREA – Do the math and find out the area of the canvas.
*VOLUME – Estimate the amount of paint needed

Art

*Where is the eye drawn to?
*Where is the horizon?
*Does s/he use foreshortening?
*How is brush strokes used?
*What is the artist's trademark?
*Where is the light source?
*SENDER/RECEIVER – In pairs, one person views and the other draws from the clues given to them.
*SIGNATURE – Look at the artist's signature what do you

notice? Does it change over the course of his career? How creative has s/he been?
*How has the artist used the negative spaces?
*What are the dominant colours?
*How have they used light and shadow?
*Can you find the light source?

Symbols

*Are there flowers in the painting? What do they symbolize?
*There are many objects used to symbolize eg love, purity, faithfulness. What if any do you see in the painting?

History

*What year was this painting completed?
*Can you find out who commissioned this canvas and why?
*See if you can historically identify the person in the painting.
*When did they live?
*What did they do?
*Who are their descendants today?
*Looking at the painting, list items and see if you can identify the country they are From.
*Historically what did artists of old use to get pigment in the paint?
*Many early works were painted to teach religious doctrines. Can you identify any teachings from this painting?
*Was this a Reformation or Counter Reformation piece?
*Did the artist have an encounter with the Inquisition?

Antoinette James
Geography

*Look at the landscape and draw an estimated topographical map.
*What season does this painting represent?
*What is the weather?
*Can you identify the landscape from maps or photos today?

Now make up questions of your own and write them below.

-----Colour In-----

What different colours shades and tones can you see in this painting?

Art apprentices of the past would copy many of the paintings of the masters. Copyrights were not infringed. It was a way of perfecting one's ability by care observation of colour and brush techniques.

Your turn, copy Noli Me Tangere:-

Antoinette James

Or, colour in this sketch. Look carefully at the shades and tones of colour in the painting

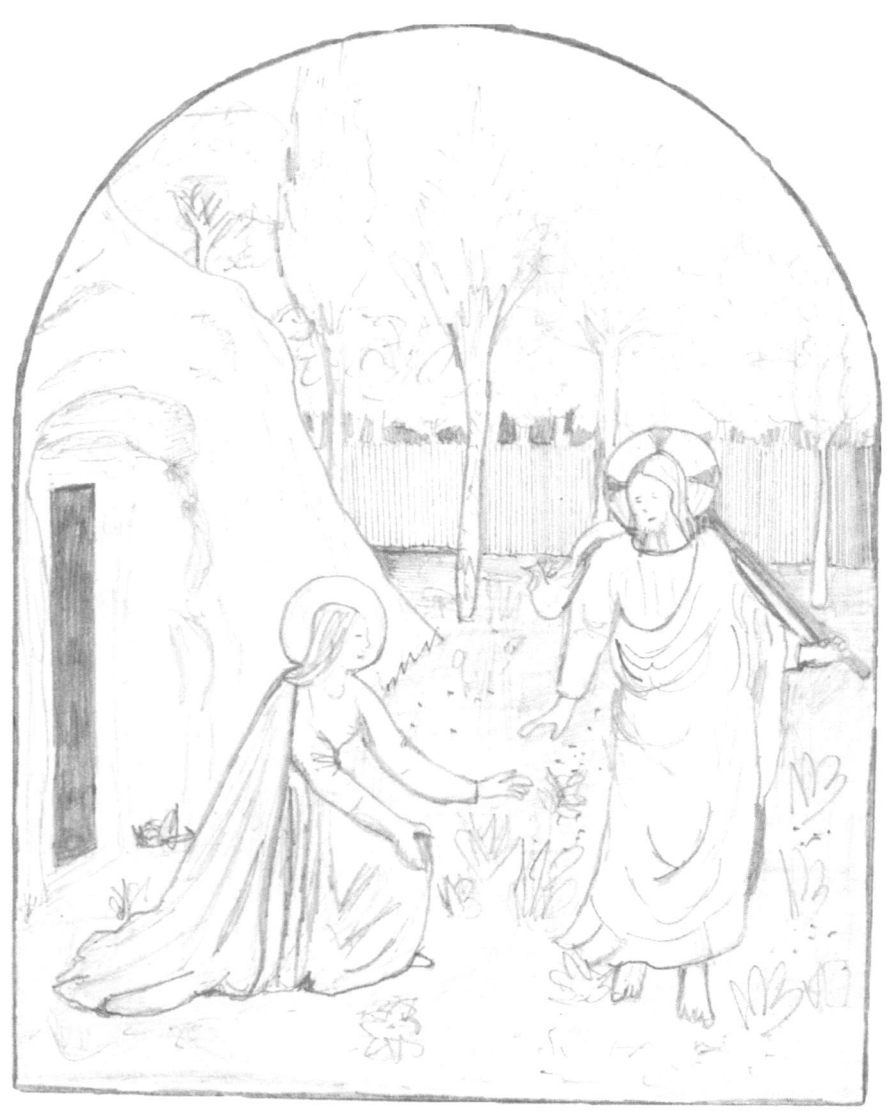

Noli Me Tangere

---Feldman's method of Art Criticism---

Art criticism is a process of saying/writing down what you think about a piece of art.

How do you do it? What do you need to know? Is it easy? Can I get it wrong? Are questions Feldman, an art educator addresses in his four-step method for the analysing or critique process.

This process is an objective noting of what one is observing. The viewer needs to be informed with context, disciplined in art, methodologically note what is painted and only then proceed to subjective declarations of liking it or not are expressed.

Description

Objective - say what you see in the work of art. This is not the time to interpret what you think is happening.
Who is the artist? His or her name
Where was it created? Location
When was it created? Date
What are the dimensions? Size – height, then width, followed by depth.
What is the subject?
Is the focal point an object?
If so what is it? Person, vase etc,
*What do I see? Not what I think I see.
*What are the facts? – Colours, number of people, etc
*What is the name of the artwork? The title
*What kind of shapes/lines/colours/textures do we see?
*What is the medium/media? Materials used eg oil on canvas
Described colour lines texture in bullet-point or paragraph.

Antoinette James

Analysis-how is the work organised?

How is the work organised? Refers back to the elements of design - line shape value which is lights and darks colour texture space.

how do they impact the work of art. Eg what role does texture play? How is light and dark used? Does line play an important role? Not all elements are going to play an important role in all pieces of art.

If colour or negative space is huge, you will then need to consider these in your critique.

*How does the artist use the elements of design in the work of art?
 Eg How are the colours used?
 What effect do they have on the artwork?
 What role does texture play in the work?
 How has the artist used light?

Look at how the artist has used the elements and principles of art to create the composition. The elements being things like line shape and form, colour value, texture space.

How does he use the principles of design to pull it all together? Principles of design would be balance contrast movement, pattern, emphasis rhyme and unity.

You could say how the artist has used texture throughout the piece to bring a sense of unity from the left to the right. The red background is unifying the whole piece, or the emphasis is on the colour red.

Talk specifically on how the artist is using the elements of art and the principles of design. You need to be specific. You can't talk about them all, granted, but choose two or three that really talk to the piece or works in the piece.

Interpretation what is it about?

What's it about what is the artist trying to say? And what evidence in the artwork supports that. So if you feel pretty strongly that the artwork for example makes a political statement or if we think the artwork is an illustration from a dream, or the artwork is an event from history use examples from the artwork to support our view. Do not be afraid to have a different opinion than other classmates. Trust your intellect and your gut, Creativity when interpreting a work of art and what the artist is trying to say.

*What is the artwork about?
*What is the artist trying to say?
*Can I express what I think the artwork is about in one sentence?
*What evidence from the artwork supports my interpretation?
*You may express your opinion, but be able to support it using evidence from the artwork.
*Use your intelligence and creativity; do not be afraid to interpret the work differently from your classmates. Interpretation. What is the message?
*Talk about I the artist was trying to accomplish if self critique.
 *Use the evidence it is hard to be wrong about it. The process is good.

Judgement- do I like it or not?

Opportunity to say if you like it or not. But will give an informed judgement before I make this claim.

Why is it that one person will like one type of art work over another? What kind of art do you like -mimics the real world or has a strong emotional content? Art critiquing is a subjective

exercise.
*Is it a good artwork?
*Do you like the artwork? Why or why not?
*What criteria do you think are most appropriate for judging the artwork?
* Are you judging the artwork based on its formal elements (use of the elements and principles of design)?
* Are you judging the artwork based on its success at imitating the real world?
* Are you judging the work based on its emotional content?
Is the work of art successful or not?

Why do I like/hate this piece of art? You will need evidence to back up your argument.
Beautiful and successful are two different things.

When you critique a work of art consider using these four steps. As you elaborate on your point don't forget to use your art vocabulary!

Elements of design

Line
Shape
Value
Colour eg warm yellows, deep turquoises, neutral background, high contrast
Texture eg feather, pears, fur robes etc luminosity of the skin ribbons
Space
Form
Light eg source ethereal light
Surface pane
Figures eg female $\frac{3}{4}$ view slight smile looking directly at us.

Principles of design

Focal point
Rhythm
Unity
Variety
Repetition
Proportion
Balance

References

- Rossetti, William Michael. Angelico, Fra. *1911 Encyclopædia Britannica*.
- Hood, William. *Fra Angelico at San Marco*. Yale University Press, 1993. ISBN 9780300057348
- Morachiello, Paolo. *Fra Angelico: The San Marco Frescoes*. Thames and Hudson, 1990. ISBN 0-500-23729-8
- Frederick Hartt. *A History of Italian Renaissance Art*, Thames & Hudson, 1970. ISBN 0-500-23136-2
- Giorgio Vasari. *Lives of the Artists*. first published 1568. Penguin Classics, 1965

www.ingramcontent.com/pod-product-compliance
Lightning Source LLC
Chambersburg PA
CBHW041116180526
45172CB00001B/284